101
OUTSTANDING
GRAPHIC NOVELS

101
OUTSTANDING GRAPHIC NOVELS

Stephen Weiner
introduction by Ellen Forney
edited by Danny Fingeroth

NANTIER · BEALL · MINOUSTCHINE
Publishing inc.
new york

ISBN 9781561639441
© 2015 Stephen Weiner
Covers and artwork © their respective owners
Introduction © 2015 Ellen Forney

Library of Congress Control Number 2014958652

Printed in China
1st printing April 2015

This book is also available wherever e-books are sold.

Acknowledgements

Courtney Allison
Stefan Blitz
Bob Bretall
Joe Corallo
Martha Cornog
Billy Cronin
Bob Dylan
Danny Fingeroth
Ellen Forney
Robin Fosdick
Stewart Fritz
Craig Shaw Gardner
Joel Hahn
Michael Hominick
Molly Jackson
Rich Johnson
Katherine Kan
Gene Kannenberg Jr.
Jr., Isaac Kelly
Sean Leslie
Andrea Levine

Andrea Lipinski
Nicola Mansfield
Marc Mason
Terry Nantier
Kristin Northrup
Joshua Ortega
Mike Pawuk
Molly Pfeiffer
Lindy Pratch
Myke Prohaska
Chris Reilly
Mark Richardson
Scott Robins
Tony Shenton
William Sleator
Jeff Smith
Nick Smith
Steve Straharik
Larry Strome
Janet Weber

Dedication

This book is for my daughter Lily, a constant surprise.
—S.W.

Introduction
by Ellen Forney

I've been a professional cartoonist for years, but I still relish the moment when someone I've just met asks me what I do. Their face almost always lights up. "Really!" The combination of mystery and familiarity with comics makes our world both exotic and welcoming.

The medium of comics is a powerful one. My first book-length graphic memoir, *Marbles: Mania, Depression, Michelangelo, and Me*, is about my bipolar disorder, and I could not have told my story in a format other than in comics. For the specifics of therapies, medications, and conversations, I needed words. To express the abstract nature of my wildly different moods, I needed the immediate, emotional power of pictures. And to make the myriad elements cohere, I needed to use every technique I could conjure up. I consciously used all that I had ever gleaned from reading other cartoonists' work, and all I had taught and learned from my students' work over the years.

I teach studio classes and graphic novels as literature to college students and teens, and I emphasize that some of their most important "teachers" will be the comics they read—especially the ones they're inspired to explore multiple times, the work of the cartoonists they admire—and their discussions with each other. Reading comics is an essential key to both appreciating and creating them.

On the first day of class, I go around the room and have the students name a couple of their favorite comics or cartoonists. There will inevitably be a huge assortment—a few into classic superheroes, several into new indies, several into manga, several that mostly read comics online, several that don't really read comics but thought the topic sounded cool. I know they will learn a ton from each other.

One of the toughest things I have to do to prepare for class is to come up with a reading list. There are some that are such classics that I'd be slacking if I skipped them: *Maus* by Art Spiegelman (brilliant, won a Pulitzer), and *Watchmen* Alan Moore (popular as a rock star) and Dave Gibbons. The memoir I recommend to friends that have never read a graphic novel is the erudite, intimate *Fun Home* by Alison Bechdel. *American Born Chinese* by Gene Luen Yang spurs rousing discussions of racism and stereotypes; creepy, lush *Black Hole* by Charles Burns is obliquely set in our hometown of Seattle; *Persepolis* by Marjane Satrapi is a poignant, eye-opening memoir of growing up in Iran.

My own list goes on and on. My colleagues have lists just as long but with many different titles. I choose some of my favorites and then build variety into the curriculum by giving the students a (perhaps overly-) lengthy "recommended" list, and they are required to read several of their own choosing.

As I tell my students, with arms spread wide: Welcome to the wide, wild, wooly world of comics! And for those of us who are already devotees: Happily, there are worlds of comics yet to discover.

Ellen Forney is a cartoonist and teacher based in Seattle, Washington, whose work has been published by Fantagraphics Books and *The Stranger* (an alternative newspaper), among other publications. She teaches at the Cornish College of the Arts. Forney received her B.A. from Wesleyan University, where she majored in psychology.

In 2007, Forney's *I Love Led Zeppelin* was nominated for a prestigious Eisner Award as Best Reality-Based Comic. She illustrated Sherman Alexie's novel for young adults entitled *The Absolutely True Diary of a Part-Time Indian*, which won the National Book Award in 2007.

Forney's book *Marbles: Mania, Depression, Michelangelo, and Me: A Graphic Memoir* was published by Penguin Books, 2012. It was named Best Graphic Novel of Fall, 2012 by Time and was a Washington Post Best Book of 2012.

Foreword to the New Edition

101 Outstanding Graphic Novels is the fourth edition of the original book, *100 Graphic Novels for Public Libraries* (Kitchen Sink Press, 1996). Two subsequent, expanded editions were published, entitled *The 101 Best Graphic Novels* (NBM 2001, 2005). Because of the "graphic novel explosion" that's occurred in the past decade or so, it became critical to publish this update. Trade publishers have created graphic novel imprints in addition to those produced by comic book publishers, the result being that choice material published in graphic novel format has never been richer. What I have tried to do in this volume is to indicate the range of materials published in graphic novel format and demonstrate that there are several outstanding graphic novels for every kind of reader. For that reason it might appear that some books by some big name creators are minimized.

In preparing this list of 101 books, I reviewed several hundred graphic novels and selected what best represented the burgeoning graphic novel field. This list could be considered an indication of the plethora of really good graphic novels available today. In addition, I surveyed critics, librarians and comic shop retailers asking for their short lists of the best graphic novels. Their input was critical in compiling the list you now hold.

That being said, any list is biased by the preferences of the person creating it. For this edition I used the most recent publication data, so while many of the books included have very recent publication dates, they may be reissues of earlier graphic novels that remain important. All books included are in print as of the writing of this book. Many of the books in this edition may be available from used book dealers or public libraries as well as from current comic book stores and bookstores, so readers are encouraged to look in many places while searching out a particular book. I have also included a few important out of print books in the "Further Reading" section which will be found in libraries or at used book dealers.

The term "graphic novels" as used in this book will mean any book in cartoon format that is bound between two covers and sold as a trade book. This list includes literary fiction as well as genre pieces, nonfiction, anthologies, and a few classic cartoon collections.

I would like to especially thank Ellen Forney for contributing the introduction. Her book, *Marbles: Mania, Michelangelo and Me: a Graphic Memoir,* itself illustrates how far graphic novels have come.

—Stephen Weiner, Boston, MA, 2015

A Short History of Comics and Graphic Novels

Historians might argue that the first comics were cave paintings depicting battles and tribal rituals, but American comics really began in 1895, with the publication of Richard Outcault's newspaper strip, *The Yellow Kid*. Comic strips caught on, and, as a result, the comic strip became very popular in the early part of the last century. Sunday and daily comic strips continue to be featured in almost every newspaper in the United States.

Comic books were first created in 1933, when Max Gaines bound some newspaper strip reprints together and sold them as a magazine. Soon publishers wanted more than reprinted stories and new material was created for this blossoming form of publishing. For many people who observe the field peripherally, the late 1930s remains a defining moment in both comic book history and popular culture; many of the superheroes who remain popular today were created in the years just prior to World War II.

As a genre, comic books mirrored popular culture. The comics published in the 1940s had a distinctly patriotic flavor—indeed many were straight-out Allied propaganda. Comics in the 1950s presented both a conservative viewpoint, found in the popular romance comics, and a growing subversive attitude, as demonstrated in the horror, crime, and science fiction comics published by EC Comics. The 1950s were also the period when the comic book field came under attack as deleterious to the morals of American youth. Dr. Frederic Wertham's book *The Seduction of the Innocent* blamed juvenile delinquency on the effect of comic books. Worried, comic-book publishers created the Comics Code Authority (CCA), which set forth guidelines for acceptable and unacceptable content. EC Comics dropped its controversial comics rather than adopt the CCA's rules, and turned its most successful magazine, *Mad,* into a newsstand periodical not bound by the new regulations. Romances and Western tales flourished.

Superhero comics returned in the late 1950s, and grew very popular in the 1960s. As America had become a more introspective society, the new superheroes, embodied by Spider-Man, were imbued with phobias and challenges. The 1960s also witnessed the emergence of underground "comix,"

which, echoing the hippie revolution, expressed discontent with middle class values. Humor, superhero, and other mainstream comic books were sold in drugstores and on newsstands. Underground comix couldn't be sold there because these comics purposefully opposed the mores supported by the CCA. Instead, the undergrounds were sold where their intended audience shopped—head shops. This was the first time anyone had attempted to niche market comics. Previously, comic book publishers had attempted to sell to the largest audience possible. But the success of the underground comix movement proved that a profit could be made by appealing directly to readers whose political ideal or artistic aesthetic were the same as the comics creators'.

In the late 1970s, the comic book specialty shop appeared. The store was an outgrowth of the comic book conventions of the 1960s, and allowed comic book retailers direct access to comic book collectors and readers. The comic book store supported mainstream comic books as well as undergrounds, perhaps because both forms existed on the fringes of society. The comic-book specialty shop thrived in part because it allowed publishers direct contact with their readership. As a result, many publishers experimented with different kinds of books, each directed at a different segment of the comic store patronage. The store gave birth to a new genre of comic-book publishers: alternative presses. Some alternative presses published work that might have been supported by mainstream publishers, but instead was brought out by small, startup publishing houses, often allowing the comic-book creator to keep more of the profits.

Other factors were important as well. Cartoonists in the United States were utilizing methods developed by Japanese and European creators, bringing a new sophistication to American comic books. Underground comix moved closer to mainstream comics, virtually disappearing, while some heroes of mainstream books expressed radical political philosophies. The graphic novel, a literary comic book form with a beginning, middle, and end, was popularized by Will Eisner's 1978 book, *A Contract with God and Other Tenement Stories,* four stories about the disenfranchised set in the Bronx during the Great Depression. The book was sold in bookstores rather than comic stores and aimed at adults.

The 1980s brought forth a new, tortured superhero. These stories were not meant for ten-year-old boys, but for a more mature audience that still wanted to read comic books. Artwork became more expressive and storylines increasingly demanding. Comic readers had to grow more literary to comprehend the involved storylines. Ironically, comic books, and their grown-

up counterpart, graphic novels, became more literate at the same time that national reading scores began to decline.

Toward the end of the 1980s and into the 1990s, the graphic novel form grew in popularity. The form had many advantages. Because it told a complete story, it became an easy way for readers unfamiliar with comic books to experience the medium. Also, regular comic-book readers who had grown tired of missing an issue in the middle of an ongoing storyline could now read the entire story arc as a whole in the graphic novel format. By the late 1990s, public libraries were adding graphic novels to their collections, and graphic novels were being awarded prizes previously given only to prose works.

In the early part of the 21st century, bookstores began adding graphic novels to their vast array of reading choices, as comics made further inroads into popular culture thanks to a string of highly successful motion pictures based on comic-book characters, serious novels set in the world of comic books, graphic novels presenting serious subjects with sensitivity, and the explosion of interest in manga that was emigrating to the United States from Japan. Since 2002, the graphic novel form has grown so popular that not only do most major bookstores have a graphic novel section, most trade publishing houses now have some kind of graphic novel publishing program. This, combined with the traditional avenues for comic-book publishing, has made the graphic novel a more visible and viable form than it's ever been in American culture, as readers are given a wider array of types of stories told in comic book form than ever before.

And who knows what the future will bring?

101 OUTSTANDING
GRAPHIC NOVELS

B., David
Epileptic
Pantheon Books, 2005
ISBN 978-0375423185
$28.95
In this deeply affecting memoir, which has been compared to James Joyce's *A Portrait of the Artist as a Young Man*, French cartoonist David B. describes his parents relentless attempts to find a remedy for his brother's epilepsy. There are three things that make this graphic novel brilliant: the depiction of epilepsy; the artist's style, which moves from the cartoony to the terrifying effortlessly and without notice; and David B.'s unflinching honesty, as he depicts his own life as a response to his brother's progressing illness.

Ba, Gabriel and Fabio Moon
Daytripper
Vertigo, 2011
ISBN 978-1401229696
$19.99
Brothers Ba and Moon have crafted a tale about impending death and the importance of living life to the fullest. Obituary writer and aspiring novelist Bras revisits several interludes in his life, with each incident ending the same way, with his death— only to have his life start again in the next chapter! Illustrated in soft, easy-to-look-at drawings, and filled with thought-provoking questions, this book will linger on long after you've closed the back cover.

Beaton, Kate
Hark! A Vagrant
Drawn and Quarterly, 2011.
ISBN 978-1770460607
$19.95
Beaton's invigorating takes on historical figures, incidents, and literary icons are insightful, poignant, and hilarious. Her subversive reworking brings new life to familiar stories. The drawings are simple, clear, and expressive. This is a collection of short strips rather than an ongoing narrative, as Dracula, the Bronte sisters, and other well known figures populate these strips. If you like humorous revisionist history, this is the book for you.

Bechdel, Alison
Fun Home: a Family Tragicomic
Mariner Books, 2007.
ISBN 978-0618871711
$14.95
In this graphic memoir, when college-age Bechdel writes her parents a letter informing them that she is a lesbian, she doesn't realize that this will allow her mother the opportunity to reveal that her late father was also gay. Bechdel's attempts to learn more about and come to terms with her remote father inform this deeply moving and ambiguous book. The line artwork is soft, and clear, the color muted, and the writing incisive. Readers may be interested in Bechdel's follow-up as well, *Are You My Mother: a Comic Drama* (Mariner Books, 2013).

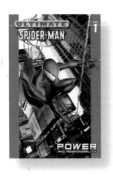

Bendis, Brian Michael and Mark Bagley
Ultimate Spider-Man: Power and Responsibility
Marvel Entertainment Group, 2009
ISBN 978-0785139409
$19.99
This reworking of Spider-Man's origin has been updated for today's readers by including modern references and splashy artwork. In a form true to the original Spider-Man from the 1960s, Spider-Man's personal problems are harder to resolve than his fights with super-villains. More stories of Spider-Man are

collected in succeeding *Ultimate Spider-Man* books. Also recommended: *The Ultimate X-Men,* by Bendis and others.

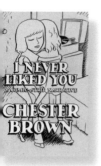

Brown, Chester
I Never Liked You
Drawn & Quarterly, 2002
ISBN 978-1896597140
$16.95
Brown's biting commentary on adolescent insecurity and search for love is moving and true to life. The book design is particularly effective in conveying teen isolation and yearning. This is one of the best graphic novels articulating a realistic coming of age. For readers who read (and re-read) J.D. Salinger's *The Catcher in the Rye.*

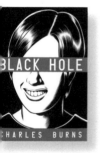

Burns, Charles
Black Hole
Pantheon Books, 2005
ISBN 978-0375714726
$19.95
In suburban Seattle during the 1970s, teenagers become afflicted with an unknown disease apparently spread through sexual activity. The disease affects different people differently: some are disfigured while some grow new body parts. Cartoonist Burns' style is both mesmerizing and horrifying as the stark black, thick lines compel the reader toward the story's conclusion. Not to be missed.

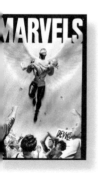

Busiek, Kurt and Alex Ross
Marvels
Marvel Entertainment Group, 2010
ISBN 978-0785142867
$24.99
Throughout the history of superhero comics, the newspaper profession has played a pivotal role. The secret identities of both Superman and Spider-Man are journalists. The protagonist of *Marvels* is a photographer who has no other identity, but tries to document how normal people feel as they walk among

the super-powered. *Marvels* probably resonates more strongly with readers familiar with the Marvel superhero universe, but is still a very compelling look at the normal-person's view of a super-world.

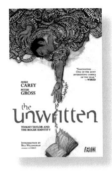

Carey, Mike and Peter Gross
The Unwritten: Tommy Taylor and the Bogus Identity
Vertigo, 2010
ISBN 978-1401225650
$14.99
In this title's fictional universe, Tommy Taylor is the son of Wilson Taylor, author of an enormously successful fantasy series featuring a hero named Tommy Taylor. Wilson has vanished and Tommy makes his living as a minor celebrity. When Tommy returns to the place of his childhood, things go awry as he realizes that not everything in his father's fantasy series was made up. Based in part on the experience of Christopher Milne's classic *Winnie the Pooh* stories), cleverly written by Mike Carey—with allusions to literary classics—and solidly illustrated by Peter Gross, *The Unwritten* is engrossing. This is the first book in a multi-book series.

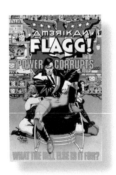

Chaykin, Howard
American Flagg!
Image Comics, 2009
ISBN 978-1582404189
$19.99
Cartoonist Chaykin's seminal series, first published in the 1980s, remains fresh. "Plexus Ranger" and media star Reuben Flagg takes on street crime and political corruption. As clever as Reuben is, he is continually outdone by gorgeous women and his talking cat, Raul. Drawn in a free-for-all style, this smart and sexy book forecast the celebrity obsession we live in the midst of today. The first of a two series set, *American Flagg!* is for mature readers.

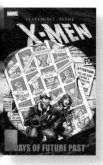

Claremont, Chris and John Byrne
X-Men: Days of Future Past
Marvel, 2011
ISBN: 978-0785164531
$19.99
This affecting X-Men storyline alternates between 1980, when the story originally appeared, and 2013, which was then the far future. A dystopian United States is ruled by killer-robot Sentinels, as mutants are hunted and placed in internment camps. The few free X-Men send Kitty Pryde back in time to prevent the steps that led to humanity's downfall. One of the most popular of the X-Men story lines after the group's rebirth in the mid 1970s, this book also forms the basis of the 2014 *X-Men* movie of the same name.

Clowes, Daniel
Ghost World
Fantagraphics Books, 2001
ISBN 978-1560974277
$11.95
Enid and Becky are codependent friends as high school ends. However, Enid's vague desire to attend college drives them apart, and Becky develops a relationship with Josh, whom

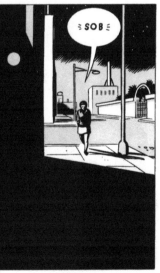
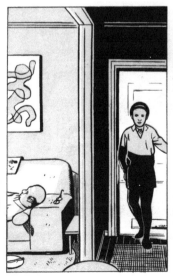
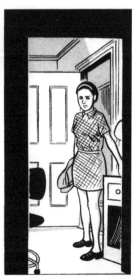

Enid also admires. Becky's relationship with Josh helps distance her from Enid. Enid's efforts to overcome her jealousy and her decision at the book's resolution is shattering and surprising, as true revelations are in all fiction, and readers are left to ponder how life decisions are made. Beautifully illustrated. (Also the basis of a 2000 feature film starring a teen Scarlett Johansen.)

Cooke, Darwyn
DC: The New Frontier, vol. 1
DC Comics, 2004
ISBN 978-1401203504
$19.99
This book re-imagines the DC heroes that formed The Justice League of America, between the end of World War II and the "second wave" of superheroes that solidified when DC created *The Justice League* comic book in 1960. The story fills in the backgrounds of Superman, Wonder Woman, Batman, Flash, Green Lantern, and The Martian Manhunter. What makes this book exemplary is not only the plot that gives these heroes the opportunity to rise again, but also Cooke's cartooning skills. He has the ability to be simultaneously warm and cold, a perfect skill when portraying the need for heroes during the early years of the Cold War. The first book in a two volume series.

Crumb, R.
The Book of Genesis Illustrated by R. Crumb
W.W. Norton & Company, 2009
ISBN 978-0393061024
$27.95
Underground comix legend R. Crumb's adult reinterpretation of *the Book of Genesis* is decisive, dramatic, and active. Told with patience and care, this mature work offers a glimpse into Crumb's softer side. The black-and-white art ranges from small panels to full pages, but is always full of detail. Notes accompany the text.

Crumb, R.
The Life and Death of Fritz the Cat
Fantagraphics Reprint Edition, 2012
ISBN 9781606994801
$19.99
This collection reprints early work by R. Crumb originally published in the 1960s and 1970s. The hero, Fritz (a streetwise funny-animal character) finds himself in a variety of hippie-style adventures and scrapes involving sexual encounters and drug use. The black-and-white line drawings are crude and expressive simultaneously. Recommended for mature readers.

Cunningham, Darryl
Psychiatric Tales: Eleven Graphic Stories about Mental Illness
Bloomsbury, USA, 2011
ISBN 978-1608192786.
$15.00
This gem examines a wide range of mental-health issues as well as Cunningham's personal experiences with mental illness. Chapters cover dementia, bipolar disorder, schizophrenia, suicide, antisocial disorder, and, perhaps most movingly, Cunningham's own struggle to overcome depression. He also notes important historical figures who suffered from mental illness, such as Winston Churchill, who is now believed to have been bipolar; Brian Wilson, who suffered from hallucinations; and Judy Garland, who was beset by anxiety and depression. These concise and poignant tales, while self-contained, build upon each other and create a framework that allows Cunningham to effectively question the stigmas associated with mental illness. His cartooning style mixes contrasting backgrounds with simple line drawings and leaves a stark impression.

Dorkin, Evan and Jill Thompson
Beasts of Burden: Animal Rites
Dark Horse, 2010
ISBN 978-1595825131
$19.99
The pets living on Burden Hill can sense paranormal dangers. This group of dogs, together with one cat, protects their world from demons, werewolves, and evil spirits in part because of their skills, their risk-taking abilities, and their luck. As opposed to a novel, this is really a collection of short stories, kind of *The Incredible Journey* infused with the supernatural. Aside from its premise, one of the things that make this book stand out is the strong characterizations. Another is Thompson's vibrant, evocative watercolors, which give this book a classic illustration feel.

Eisner, Will
The Best of the Spirit
DC Comics, 2005
ISBN 978-1401207557
$14.95
The Spirit, a newspaper-insert comic book originally published in the 1940s and early 1950s, was recognized for its ironic storytelling, strong female characters, and innovative visuals. In it, police detective Denny Colt, thought dead, fights crime as the Spirit, a superhero wearing a business suit and eye mask. This volume features some of the best-loved *Spirit* stories, including the Spirit's origin, as well as his tangles with Silk Satin, Sand Saref, and others. The character and the series were the creation of the legendary Will Eisner, who would go on to be one of the founders of the modern graphic novel with his 1978 *A Contract With God*.

Eisner, Will
The Contract with God Trilogy
W.W. Norton, 2005
ISBN 978-0393061055
$35.00
This book collects three of Eisner's books, all depicting life on the imaginary Dropsie Avenue in the Bronx: *A Contract with*

God and Other Tenement Stories, *A Life Force*, and *Dropsie Avenue: the Neighborhood*. *Contract,* which consists of four thematically linked stories, focuses on the story of Frimme Hersh, a good man who feels that God has betrayed him. First published in 1978, *Contract* is also recognized by many as the first modern graphic novel. *A Life Force*, one of Eisner's most realized works, tells the story of Jacob Shtarkah, a carpenter with a weak heart and a poetic bent, intent on living a meaningful life. *Dropsie Avenue* chronicles the changing life on Dropsie, from the arrival of Dutch immigrants in the 1600s, and follows waves of immigration and the changing political climate through American history, in the microcosm of one city block.

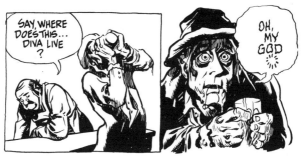

Forney, Ellen
Marbles: Mania, Depression, Michelangelo, & Me, a Graphic Memoir
Gotham Books, 2012
ISBN 978-1592407323
$20.00
Forney's memoir of her journey into the heart of a bipolar life and her voyage out with the help of her therapist and mother is inspirational, affecting and instructive. Her squiggly black illustrations and clear narration successfully enable readers to experience the instantaneous happiness of the up-side of polarity, as well as the debilitating fall. This book is also notable for its exploration into the relationship between mental illness and creativity. That Forney has studied these issues in such detail is remarkable, and that she is able to communicate what's she's learned, amazing.

Fraction, Matt and David Aja
Hawkeye: My Life As A Weapon
Marvel, 2013
ISBN 978-0785165620
$16.99
This series tells the story of the Avengers superhero team member, Hawkeye, but it focuses on the archer's life apart from the team. Stories are populated with New York City's down-and-out, as well as super villains. Into the mix comes Kate Bishop, another Hawkeye. The odd partnership between the two forms the core of these stories. This volume includes the story of how the two Hawkeyes met. Dialogue is sure, the science is sound, and the visuals brilliant. This ongoing series is lots of fun.

Gaiman, Neil, et al
The Books of Magic
Vertigo/DC Comics, 2013
ISBN 978-1401237813
$24.99
In a story reminiscent of the work of British fantasists Alan Garner and Susan Cooper, young Tim Hunter reluctantly joins a magic circle that he will someday rule. Arthurian fantasy doesn't translate into the graphic novel medium better than this.

Gaiman, Neil, and P. Craig Russell
Coraline
HarperCollins Reprint edition, 2009
ISBN 978-0060825454
$9.95
This graphic novel adaptation of Gaiman's 2002 prose novel of the same name is as haunting as the original. When bored Coraline opens the door to the other side of the house, she meets her "other mother," who has plans for Coraline's real parents. Coraline must then ask herself what it is she really wants, how she can get it, and how she can save her parents! Illustrated in precise, exacting illustrations, and powerfully colored to effectively dramatize the story.

Gaiman, Neil, et al
The Sandman, vol. 2: *The Doll's House*
Vertigo/DC Comics, 2010
ISBN 978-1401227999
$19.99

Gaiman's *The Sandman* monthly series was a reinvention of a minor 1940s hero, and Gaiman drew extensively on world mythologies, binding storylines of fragile humans and deities older than gods to create a seamless tapestry upon which compelling stories are told. Sandman was mainstream comics' most serious attempt to create a new mythology for adults, and this particular story, *The Doll's House,* articulates Gaiman's answer as to why gods exist. Other titles include *Brief Lives, Dream Country, The Dream Hunters, Endless Nights, Fables and Reflections, A Game of You, The Kindly Ones, King of Dreams, Preludes and Nocturnes, The Quotable Sandman, The Sandman Companion, Season of Mists, The Wake,* and *World's End.*

Geary, Rick
The Borden Tragedy: A Memoir of the Infamous Double Murder at Fall River, Mass., 1892
NBM, 1997
ISBN 978-1561631896
$9.99

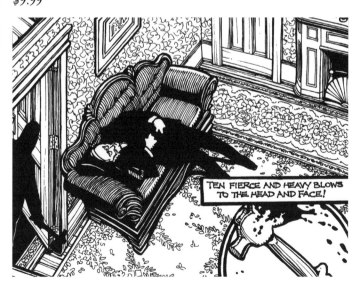

Geary, Rick
Jack the Ripper:
A Journal of the Whitechapel Murders 1888-1889
NBM, 2001
ISBN 978-1561633081
$9.99

These two little books are part of Geary's "Treasury of Victorian Murder" series. *The Borden Tragedy* presents a restrained account of the infamous double slaying, as told by an anonymous observer close to the Borden family. Readers sympathize with the publicly-smeared Lisbeth "Lizzie" Borden, and are relieved at the trial's outcome. Geary wryly notes the similarities between the Borden trial of the 1890s and the O.J. Simpson trial of the 1990s. In *Jack the Ripper,* Geary turns an impartial and clear eye on the horrific crimes committed against prostitutes in Whitechapel. The illustrations are poignant, unsentimental, and move the narratives along handily. Both volumes include a bibliography.
(See also Alan Moore & Eddie Campbell's *From Hell.*)

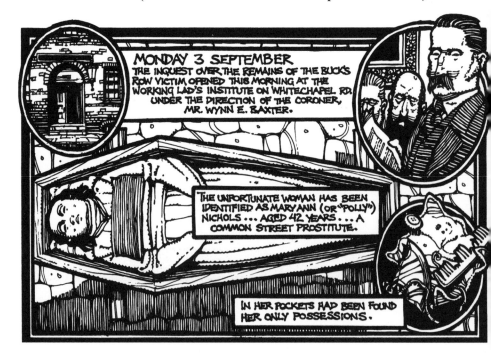

Glidden, Sarah
How to Understand Israel in 60 Days or Less
Vertigo, 2011
ISBN 978-1401222345
$19.95
Glidden's autobiographical Birthright trip/tour of Israel is full of information, but more importantly, it's full of personality, as Glidden takes advantage of a free trip to Israel, hoping to learn more about her Jewish heritage and herself. While she tries to separate information from propaganda, she is forced to question her own biases, preconceptions and misconceptions. The art is serviceable if not spectacular but the personal crisis this book focuses on is profound.

Gonick, Larry
Larry Gonick's The Cartoon History of the Universe
Doubleday, 1997
ISBN 978-0385265201
$22.95
One of the most popular, widely read and reviewed books in the graphic novel format, this bookprovides clear, historical information, using a visual orientation and a humorous approach.

Goodwin, Archie & various artists
Tales of the Batman
DC Comics, 2013
ISBN 978-1401238292
$39.99
This book collects Batman stories written by Archie Goodwin and illustrated by various artists from 1973-2000. The stories are well-produced and re-colored for this edition.
One of the aspects that makes this volume special is the inclusion of the Goodwin-penned *Batman/Manhunter* stories from the 1970s. Creatively illustrated by Walter Simonson, this storyline reinvented *Manhunter*, an embittered but moral hero, brought back from death to serve an international secret organization. How Manhunter wins his life back forms the core of this storyline. The *Batman/Manhunter* story won six industry

awards when it first appeared, although it was a story only seven short chapters long.

Hernandez, Gilbert
Palomar: The Heartbreak Soup Stories
Fantagraphics, 2007
ISBN 978-1560977834
$14.95
A mythical Latin American village, Palomar is a town whose residents live out unexceptional lives. Then Luba arrives, becoming one of the leaders of Palomar. This book chronicles the events in the town from Luba's arrival to her departure twenty years later. Cartoonist Gilbert Hernandez and his brother Jaime co-created *Love & Rockets* in the early 1980s, from which thesestories are selected. *Love & Rockets* encompassed a broad ensemble of characters, and broke new ground in both the subject matter and the way comics stories were told. The book was identified as one of the secret masterpieces of American fiction by *Rolling Stone* magazine, and appealed to female as well as male readers. Some of Jaime's stories have been collected in the companion volume to *Palomar, Locas: The Maggie and Hopey Stories.*

Hicks, Faith Erin
Friends with Boys
First Second, 2012
ISBN 978-1596435568
$15.99
Maggie and her brothers have been homeschooled by her mother, who has left the family without any explanation, as Maggie begins ninth grade at the local public high school. She is befriended by outcast brother-and- sister duo Alistair and Lucy. Lucy has a fascination with graves and dead people, which echoes Maggie's search for reasons why her mother left. Meanwhile, we wonder why Alistair suddenly left his group of friends to hang around with his little sister and her new friend, and whether or not there's a price to pay if a girl's friends are only boys. Hicks is an accomplished and compassionate storyteller with a deft touch. This deceptively simple, little, black-and white book asks a lot of big questions.

Holm, Jennifer and Matthew Holm
Babymouse: Queen of the World
Random House Books for Young Readers, 2005
ISBN 9780375832291
$6.99
In this book for very young readers, told in charming, crowded, black-and-white drawings and sharp dialogue, Babymouse is tired of the daily grind of school and homework, and longs to be queen, a title she imagines would bring only happiness. Through a series of surprising events, Babymouse does become queen. Although royal life has its advantages, she misses her old, best friend and her old life, so she returns to them.

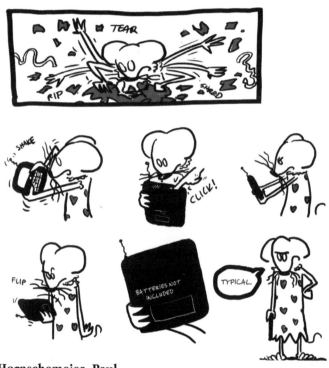

Hornschemeier, Paul
Mother, Come Home
Fantagraphics, 2009
ISBN 978-1560979739
$22.99
Mother, Come Home tells the story of a father and son's attempts to recover from the death of the family's mother

from cancer. Each retreats into a fantasy world of
his own—the protagonist into a child's power
fantasy, while the father suffers a breakdown.
Brilliantly illustrated in soft, cartoony drawings,
the story's conclusion is genuine, unforced,
and shattering. One of the most honest
graphic novels ever published.

Johnson, Crocket
Barnaby, vol. 1
Fantagraphics, 2013
ISBN 978-606995228
$35.00
This first book in a projected series reprinting
Barnaby, a comic strip that was originally published
in the 1940s and reflected the reality of the WWII
home front through the eyes of 5-year-old Barnaby.
Many colorful characters round out the strip, includ-
ing fairy godfather O'Malley, whom only Barnaby sees.
This unsentimental child's-eye view predates Schulz's
Peanuts. The line drawings are clear and evocative
and the dialogue sure. This durable edition includes
biographical information and photos of cartoonist
Johnson.

Kibuishi, Kazu
Amulet: The Stonekeeper
Graphix, 2008
ISB 978-0439846813
$12.99
Following the death of their father, Emily, Navin, and
their mother move into a family home which proves
both reassuring and dangerous. When their mother is
lured through a mysterious door in the basement, the
children follow, only to land in a world full of talking
animals, robots and monsters. Well-paced storytell-
ing, strong page design, and powerful coloring make
this humorous and terrifying fantasy a very satisfying
read. Part of an ongoing series.

Kibuishi, Kazu
Flight, vol. 1
Villard Books, 2007
ISBN 978-0345496362
$19.95
The *Flight* anthology series showcases shorter pieces by the best upcoming cartoonists. Tales range in tone from fantastic to realistic. The books are very well produced and pleasingly designed. This multivolume series is a good introduction to the work of many cartoonists and types of stories. There is also a companion series, specifically aimed at young readers, called *Flight Explorer*.

Kim, Derek Kirk
Same Difference
First Second, 2011
ISBN 978-1596436572
$16.99
This early collection from accomplished cartoonist Kim is stunning, displaying both a wide imagination and a variety of storytelling and cartooning skills. The title story focuses on twentysomethings Nancy and Simon, both with guilt on their consciences: Simon, for turning down a date with a friend because she was blind, and Nancy, for reading love letters meant for someone else and then answering them, giving the jilted ex-boyfriend hope. Through a series of credible coincidences, both Nancy and Simon make amends. What Kim does as well as anybody is portray the uneasy, vague, and lost feeling often experienced in late adolescence and early adulthood. The other stories included in the collection are shorter and cover weed-whacking, familial relationhips, celebrity interviews, high school experiences, and autobiographical tales, all told in clear, humorous, black-and-white pictures.

Kirkman, Robert and Charlie Adlard
The Walking Dead: Compendium 1
Image Comics, 2009
ISBN 978-1607060765
$59.99
[This enormous book collects issues 1-48 of the Walking Dead series.]
In a world where the undead outnumber the living by an incredible margin, police officer Rick Grimes leads a small group of the living to a safe haven away from the "walkers" (the undead). While the ongoing plot focuses on the tension between the living and the dead, the series hinges on spot-on dialogue, sharp character development, and conflict within the human society. Graced with subtle black-and-white art that is both distinct-looking and traditional, *The Walking Dead* was awarded a Will Eisner Award for "Best Continuing Series" in 2010, and is the basis of the television program of the same name. It's also in part responsible for the zombie craze that has swept this country for the last decade. Part of an ongoing series, this book is for horror fans and more.

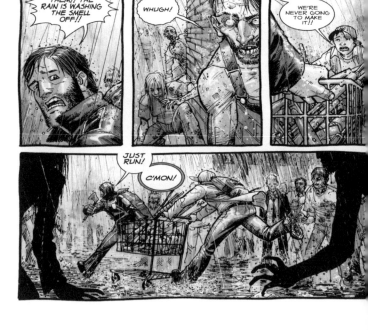

Koike, Kazuo and Goseki Kojima
Lone Wolf and Cub Omnibus, vol. 1
Dark Horse Manga, 2013
ISBN-13: 978-1616551346
$19.95
Lone Wolf and Cub is the story of a lone samurai, Ogami Itto, who is framed as a traitor by agents from a rival clan. With his wife murdered and with an infant son to protect, Ogami chooses the path of the ronin, the masterless samurai. Ogami and his son wander feudal Japan, Ogami's sword for hire, but all roads will lead them to a single destination: vengeance. Meticulously rendered and well researched, *Lone Wolf and Cub* was one of the first Japanese comics to reach U.S. shores, and it heavily influenced American cartoonists in the 1980s. Part of a multi-volume series published by Dark Horse, telling the entire saga of *Lone Wolf and Cub.*

Kuper, Peter
The Metamorphosis (Franz Kafka, author)
Broadway Books, 2004
ISBN 978-1400052998
$10.95
Kuper's interpretation of the famous Franz Kafka story about Gregor Samsa waking one day to find that he'd been transformed into a giant insect is precise and haunting. Kuper's use of solely black-and-white illustrations brings out the isolation inherent in the story, and his well placed narration moves the story along visually as well as content-wise. A good introduction to the works of Kafka, perhaps a better introduction to the works of Peter Kuper.

Lee, Stan, and Steve Ditko
The Amazing Spider-Man, vol. 3 *(Marvel Masterworks)*
Marvel First Edition, 2009
ISBN 978-0785136965
$24.95

Lee, Stan, and Jack Kirby
The Avengers, vol. 1 *(Marvel Masterworks)*
Marvel, 2009
ISBN 978-0785137061
$24.95

Lee, Stan, and Jack Kirby,
Fantastic Four, vol. 1 *(Marvel Masterworks)*
Marvel First Printing Edition, 2009
ISBN 978-0785137108
$24.95

Lee, Stan, and Jack Kirby,
X-Men, vol. 1 *(Marvel Masterworks)*
Marvel GPH edition, 2009
ISBN: 978-0785136989
$24.95
The "Masterworks" volumes reprint classic Marvel comics in color. These volumes range from *the Avengers—*Marvel's answer to the *Justice League*, featuring its greatest heroes banded together in heartfelt, entertaining tales of heroism—to *the Fantastic Four—*the landmark series that kicked off the revitalization of the superhero genre in 1961—to *Spider-Man,* to *the X-Men,* defining modern heroes caught between responsibility and self-fulfillment.

Lemire, Jeff
Essex County
Top Shelf Productions, 2009
ISBN 978-1603090384
$29.95
Winner of Canada's Joe Shuster and Doug Wright awards, *Essex County* collects Lemire's three interlocking graphic novels focusing on hockey, all set in Essex County. The trio is *Tales from the Farm, Ghost Stories,* and *The Country Nurse,* as well as previously unpublished material. Each story reveals a family secret and each builds upon the other. Illustrated in a subtle black and white, the work shows Lemire to be an emotive

and gripping cartoonist. One can see the influence of Mike Mignola and Frank Miller in his work.

Lemire, Jeff
Sweet Tooth vol. 1: *Out of the Woods*
Vertigo, 2010
ISBN 978-1401226961
$12.99
In a futuristic world, Gus is a new breed, half human, half animal. In his case he's half deer. He's been living in the woods with his bible-toting father, and has never seen another human being. After his father dies, hunters capture Gus. One of them, Jepperd, promises to take Gus to a sanctuary. But can he trust Jepperd? Gus follows for the candy (hence the nickname Sweet Tooth) and the companionship. Another extraordinary outing for Lemire—his illustrations are both suggestive and emotive, and illustrated in full color with panels shrinking and growing to fit the story. The pacing is confident and the dialogue sharp. The first volume in a five book series.

Lewis, John, Andrew Aydin, and Nate Powell
March: Book 1
Top Shelf Productions, 2013
ISBN 978-1603093002
$14.95
This graphic autobiography of Congressman John Lewis recounts his humble beginnings on a small chicken farm, to the early days of the Civil Rights movement, when he was one of the first people possessing the courage necessary to break the color line, which he did with the help of Dr. Martin Luther King and Jim Lawson. The intentionally washed-out black-and-white illustrations give this text-heavy narrative a sweeping and personal feel. The first book in a projected trilogy, *March* was a 2014 Coretta Scott King Honor Book.

Mazzucchelli, David
Asterios Polyp
Pantheon Books, 2009
ISBN 978-0307377326
$35.00

Genius professor Asterios Polyp finds himself alone and adrift at 50 after his Manhattan apartment burns. Working as a mechanic, he lives with the family that employs him, and finds the strength to confront his old life. Told in a series of flashbacks and set against a backdrop of Greek mythology, the story of Polyp's life unfolds: his childhood intellectual explorations, his lovers, and his twin who died at birth, whose loss he still feels. This book is not only singular for its story but for the generous and sweeping artwork: the illustrations open into each other and the judicial use of color adds to the drama. Mazzucchelli employs many art styles in order to achieve his effects, and reading this book is in part a fascinating walk through the history of visual storytelling.

McCloud, Scott
Understanding Comics: The Invisible Art
William Morrow Paperback, 1994
ISBN 978-0060976255
$22.95

A best seller when it first appeared and a perennial seller ever since, *Understanding Comics* is a graphic novel about how comics work. McCloud cleverly guides readers through different facets and stages of the creative process, making this book applicable to creative fields outside of comics. McCloud's cheeky

characterization of himself amuses readers as he espouses theories on comics, art, and creativity. Gorgeously illustrated in black-and-white with multiple references to classic works of art, this is one lesson you won't want to miss. McCloud's follow up books include *Reinventing Comics* and *Making Comics*.

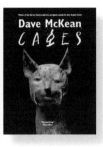

McKean, Dave
Cages
Dark Horse Books, 2010
ISBN 978-1595823168
$29.99
McKean is possibly the best known of the current artists creating work for adults, chiefly due to his prolific cover artwork in both "mature readers" comics such as *Sandman* and in books. *Cages* is the only work that McKean has written as well as drawn, and he uses the opportunity to present a dialogue on the hazards and rewards of creativity. *Cages* tells the story of three different artists: Leo Sabarsky, a painter in need of inspiration; Angel, a nightclub musician, who seems oblivious to the adulation of his audience; and Jonathan Rush, whose novel *Cages* so enraged readers that he lives in captivity. How these characters break free of their mental cages forms the conflict of this book, which evolves into a meditation on creativity and godhood. The artwork is dynamic, and changes as McKean feels appropriate.

Medley, Linda
Castle Waiting, vol. 2: *The Definitive Edition*
Fantagraphics Books, 2013
ISBN 978-1606996331
$29.95
Echoes of fairy tales and classic children's literature abound in this Eisner-award-winning series that was published as a serial over a number of years and then collected in 2006. *Castle Waiting* tells the story of a rundown castle brought back to life by its quirky inhabitants, many of whom have had mythic difficulties. These stories focus on the ways these characters bring the old castle to life by making it their home. With clear, no-nonsense black-and-white illustrations and strong characters, this is a book to savor and re-read.

Mignola, Mike
Hellboy: Seed of Destruction
Dark Horse Books, 2004
ISBN 978-1593070946
$17.95
Originally summoned from the depths of hell by the Nazis, Hellboy turned against them and became Earth's greatest paranormal investigator, determined to protect humanity from the forces of evil. A team composed of both mutants and humans aids him in his quest. Mignola's style was, and remains, trend-setting: at once humorous, dramatic, arresting, and pleasing. The series has branched out into prose novels and movies. Other titles are: *Wake the Devil, The Chained Coffin and Others, The Right Hand of Doom,* and *Conqueror Worm.*

Millar, Mark and Dave Johnson
Superman: Red Son
DC Comics New Edition, 2014
ISBN 978-1401247119
$14.99
In this offbeat tale that begins in the 1950s and continues through the end of the 20th century, Superman is, as in most versions of his origin, launched as a baby from Krypton and lands on Earth. In *Red Son,* though, he lands not in the

American heartland, but in the Soviet Union, where he becomes that land's national hero. Alternate versions of politicians such as John F. Kennedy and Josef Stalin intermix with Batman, Lex Luthor, and Wonder Woman in this offbeat take on a possible alternate life of the Man of Steel.

Miller, Frank and Klaus Janson
Batman: The Dark Knight Returns
DC Comics, 1997
ISBN 978-1563893421
$19.99

Miller, Frank and David Mazzucchelli
Batman: Year One
DC Comics, 2007
ISBN 978-1401207526
$14.99

These two volumes, along with the 1989 feature film, led a resurgence in popularity for this superhero icon. In *Dark Knight*, a fine study of vigilantes and violence, Batman, at age 50, emerges from a ten-year retirement to save Gotham City from gang warfare and his nemesis, the Joker. In *Year One*, a partial source for the 2005 film *Batman Begins*, Miller and Mazzucchelli return to the origins of the character, and retell the first year of the life of the caped crusader after Bruce Wayne decides to don a costume and fight crime.

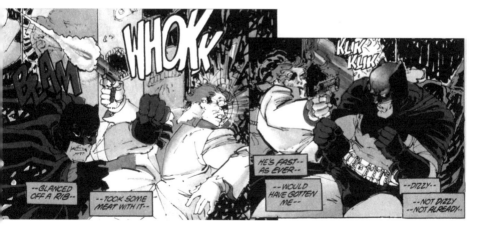

Miller, Frank and David Mazzucchelli
Daredevil: Born Again
Marvel, 2010
ISBN 978-0785134817
$19.99
Miller and Mazzucchelli tell this pivotal story of Daredevil, a blind, acrobatic hero, who "sees" by using a radioactive "radar sense." Daredevil's enemy, the Kingpin, learns his secret identity and uses the information to destroy him.

Modan, Rutu
Exit Wounds
Drawn & Quarterly, 2008
ISBN 978-1897299838
$19.95
In the wake of a Tel Aviv bombing, Israeli cabbie Kobe Franco is drawn into the search for his absent father, Gabriel, who may have been killed. Kobe's guide on this journey is his father's lover, Numi, a woman Kobe's age. As the mystery deepens as to whether or not his father is alive, both Kobe and Numi confront how little each of them knows of Gabriel. With crisp, revealing dialogue, and descriptive, understated art, the questions this story asks linger in the readers' mind long after the book closes.

Moore, Alan & Steve Bissette
Saga of the Swamp Thing, book 1
Vertigo/DC Comics, 2012
ISBN 978-1401220839
$19.99
The *Swamp Thing* comic explored what constitutes being human, through the tale of biologist Alec Holland, transformed into a swamp creature by an explosion. With scant trace of humanity left in his body, the Swamp Thing begins his journey back to that lost humanity. *The Saga of the Swamp Thing* sees Moore and Bissette building on Len Wein and Berni Wrightson's foundation to explore issues of the human condition in greater depth.

Moore, Alan and Dave Gibbons
Watchmen
Warner Books, 1995
ISBN 978-0930289232
$19.99
Moore and Gibbons offer what many consider to be
the ultimate superhero story in the form of a meditation on
time and the burdens of power. In a fantasy world, Richard
Nixon never resigned after Watergate, and superheroes
were outlawed. Those with normal (acrobatic, scientific)
abilities went into hiding; Dr. Manhattan, a man atomically
empowered by an explosion, was exempted, as he worked for
the government. The disappearance of Dr. Manhattan brings
the lesser heroes/vigilantes out of hiding, and humanity must
face the result in this compelling examination of how the
presence of super-powered individuals can truly change the
world. Adapted into a movie.

Moore, Terry
Strangers In Paradise, Pocket Book 1
(Strangers in Paradise Pocket Book Collection)
Abstract Studio; 1ST edition
2004
ISBN 978-1892597267
$17.95

The serial *Strangers in Paradise* tells the stories of twenty-somethings Katchoo, explosive and independent, and Francine, whose idea of a day well spent is returning a bird's egg to its nest. When newcomer David comes between them in this volume, there's not only jealousy and rejection in the mix, but Katchoo's dark past, which David somehow brings with him. While *Strangers in Paradise* is noteworthy for its fine characterizations and human dramas, it is also a good example of how the comics medium can merge with other forms; some of the book appears as prose, and the title, "I Dream of You," is a song. A good book for those who don't read comics, an even better book for those who do. The entire series is collected in six paperback books as well as a two-volume omnibus.

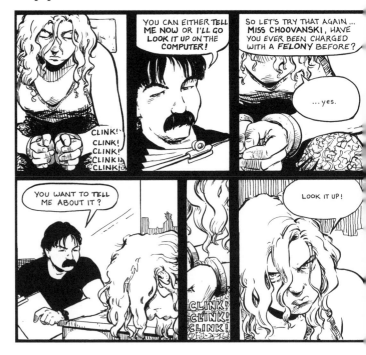

Morrison, Grant and Frank Quitely
All Star Superman
DC Comics, 2011
ISBN 978-1401232054
$29.99
The creative team of Morrison and Quitely tells this story of Superman fatally infected with solar radiation. As the end draws near, he relives moments of his past while forging deeper and new relationships with familiar characters Lois Lane, Jimmy Olsen and enemy Lex Luther, as Morrison and Quitely deliver a taut, gripping story, brilliantly illustrated with evocative, soft color, and understated art.

Nakazawa, Keiji
Barefoot Gen: A Cartoon Story of Hiroshima
Last Gasp, 2004
ISBN 978-0867196023
$14.95
The clear cartoons in this story convey an important history of World War II in a very accessible format. Originally published in Japan, this series influenced Art Spiegelman, who wrote the introduction.

North, Ryan with Braden Lamb and Shelli Paroline
Adventure Time, vol. 1
Boom Entertainment, 2012
ISBN 978-1608862801
$14.95
Based on the popular show of the same name on the Cartoon Network, this playful volume collects issues 1-4. The series is carefully plotted and designed, and begins the adventures

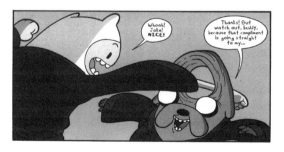

of Jake the Dog, Finn the Human, Princess Bubblegum, and Marceline the Vampire Queen in the comical world of Ooo. The absurdity mounts as these characters face threat after threat. The zany plotline is highlighted by the creative story, art, page design, and dead-on coloring. For the 10-year-old in all of us. Part of an ongoing series.

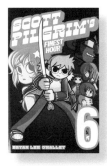

O'Malley, Brian Lee
Scott Pilgrim's Precious Little Boxset
Oni Press, 2010
ISBN 9781934964576
$72.00
This collection includes all six of the *Scott Pilgrim* books, the manga-influenced YA comics series that was made into a popular movie starring Michael Cera. Scott's quest is to win the heart of the girl he loves. But first he must defeat her seven evil boyfriends. The story is fast paced and zany, the dialogue crisp and funny, and the art matches the story's frenetic pace frame for frame. You could buy just the first volume, but you'll end up reading all six anyway.

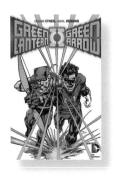

O'Neil, Dennis and Neal Adams, et al
Green Lantern/Green Arrow
DC Comics, 2012
ISBN 978-1401235178
$29.99
In this chapter of the *Green Lantern/Green Arrow* series, the heroes confront drug abuse and racism in groundbreaking stories originally published in the 1970s. Though the stories may seem dated to some, they are important parts of superhero comics history.

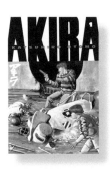

Otomo, Katsuhiro
Akira, vol. 1
Kodansha Comics, 2009
ISBN 978-1935429005
$24.99
Set in the year 2030, 38 years after World War III, *Akira* tells the story of two motorbiking teenagers

who encounter a child with the features of an old man. When one of the teens manifests supernatural powers that threaten him, both teens become involved in a war between two agencies, both intent on saving the world. With artwork that seems bigger than the page it's drawn on, *Akira* is a book that engrosses and involves the reader. This is a multi-book series.

Pekar, Harvey, R. Crumb and others
American Splendor and More American Splendor
The Life and Times of Harvey Pekar
Ballantine Books, 2003
ISBN 978-0345468307
$24.00
Pekar, who died in 2010, was a comics visionary—one of the first writers to see the potential of comics in chronicling the heroic aspects of ordinary lives. The stories in these collections depict his life as a record collector, his artistic struggles, and daily problems such as making sure the car had enough gas. Different illustrators highlight particular aspects of these stories. Vignettes illustrated by R. Crumb are sprinkled throughout this book. *American Splendor* was the inspiration for a feature film of the same name. With an Introduction by R. Crumb.

Pini, Wendy and Richard Pini
The Complete ElfQuest, vol. 1
Dark Horse Books, 2014
ISBN 978-1616554071
$24.95
One of the earliest ongoing graphic novel series, *ElfQuest*'s story of a race of elves looking for their homeland is both arresting and entertaining. Storytellers Wendy and Richard Pini weave aspects of mysticism, European mythology, and Native American lore into this tale. Beginning in 2014, Dark Horse Books started reproducing the entire series in a new format.

Pope, Paul
Battling Boy
First Second, 2013
ISBN 978-1596431454
$15.99
Veteran cartoonist Paul Pope delivers an energetic, fast-paced story of fragile humans and car-eating monsters in this colorful, compelling story. When hero Haggard West is killed, a new hero must emerge. Although West's daughter assumes she will take on the challenge, a boy from another world, "Battling Boy," who receives powers from animal illustrations on his shirts, arrives and temporarily fends off the monsters, only to find that when the monsters return he doesn't have enough weapons in his arsenal to vanquish them a second time. The first book in a series for young adult and older.

Rabagliati, Michael
Paul Joins the Scouts
Conundrum, 2013
ISBN 978-1894994699
$20.00
The *Paul* stories are an ongoing semi-autobiographical series. In this installment, Paul blossoms as a scout and experiences the turmoil of early adolescence, as his world is rocked with violence. Bordering on sentimentality, cartoonist Rabagliatti deftly walks a very fine line, and as a result, the book has a warm and

genuine feel. The black-and-white art charms with its clarity and understatement. Other *Paul* books include *Paul Goes Fishing*, *Paul Moves Out*, and *Paul has a Summer Job*.

P. Craig Russell
The Fairy Tales of Oscar Wilde: The Birthday of the Infanta
NBM Publishing, 2014
ISBN 978-1561637751
$8.99
This is one of a series of adaptations of Wilde's stories, which is handsomely presented and preserves the mythic quality of the tales by utilizing a colorful cartoon format. Other titles include *The Selfish Giant and the Star Child* and *The Young King and the Remarkable Rocket*.

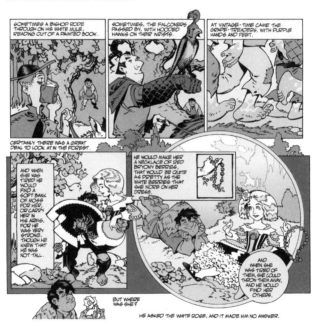

Sacco, Joe
Palestine
Fantagraphics, 2001
ISBN 978-1560974321
$24.95
A comics journalist whose style is influenced by Tom Wolfe and Robert Crumb, Sacco has worked

for *Newsweek* and received a Guggenheim. This book details his experiences during visits to the West Bank and Gaza Strip, and the information is presented in a clear, articulate manner. Also recommended are Sacco's *Safe Area Goradze: the War in Eastern Bosnia, 1992-95* and *The Fixer.*

Sakai, Stan
Usaji Yojimbo, book 1: *The Ronin*
Fantagraphics, 1987
ISBN 978-0930193355
$16.99
Japan in the seventeenth century was a time of great political unrest, with the samurai as the ruling class. Recalling western movies such as *Shane, Usagi Yojimbo* is a wandering, masterless samurai for hire. Sakai deftly portrays the protagonist (a rabbit samurai) as honorable and tortured while somehow wrapping the character in an engaging, lively, and mildly humorous tale. This is an ongoing series with sixteen books in print.

Satrapi, Marjane
The Complete Perspolis
Pantheon, 2007
ISBN 978-0375714832
$24.95
Satrapi, a successful children's book writer, recounts the story of growing up under the repressive Iranian regime and her escape from, and eventual return to, that world. The childlike illustrations counter the story's pervasive sense of oppression.

Seth
It's a Good Life if You Don't Weaken
Drawn & Quarterly, 2003
ISBN 978-1896597706
$24.95
This bittersweet autobiographical tale tells of Seth's attempts at maturity as he drifts in and out of relationships while searching for information about "Kalo," a cartoonist who placed a piece with the *New Yorker* magazine in the 1950s. The pacing is meditative, and the book is kindly drawn. While readers might squirm at Seth's self-delusions, the conclusion teaches us of the redemptive power of art.

Sfar, Joann and Lewis Trondheim, with various artists
Dungeon: Twilight-Dragon Cemetery
NBM, 2006
ISBN: 978-1561634606
$12.95
The *Dungeon* series, originally published in France, provides a satirical take on the sword-and-sorcery genre, especially on

role-playing games such as *Dungeons and Dragons*. Created by acclaimed talents Sfar and Trondheim, the world of *Dungeon*, split up into different subseries covering its rise, zenith and demise, is populated by anthropomorphic animals and other odd creatures. This installment, "Twilight-Dragon Cemetery," features Marvin, an old, blind dragon who must carry out one last mission: to find the legendary dragon cemetery. Marvin, at turns charming and maddening, teams up with a bat and an heroic red rabbit, the latter of whom is also named Marvin. The friends help dragon-Marvin face the Grand Khan, with whom the blind dragon has a score to settle. With its cartoony—yet gritty—art style, *Dungeon* takes the reader into a fascinating new world.

Shanower, Eric
Age of Bronze, vol. 1: *A Thousand Ships*
Image Comics, 2001
ISBN 978-1582402000
$19.95
Shanower has taken on an ambitious project with *Age of Bronze*, a seven-volume retelling of the Trojan War. Meticulously researched, this book tries to treat the war as history rather than mythology, and renders the world with a bronze look while exploring the social, political, and sexual aspects of the most famous war in Western literature. The sequel volume is also available, entitled *Sacrifice*.

Simonson, Walter
The Mighty Thor, vol. 1
Marvel, 2013
ISBN 978-0785184607
$24.95
Originally appearing in comic books in the early 1960s, *Thor* has become a staple of the Marvel movie franchise. These stories present writer/ artist Walter Simonson's landmark take on Thor, originally published in the 1980s. In this installment, Thor is stripped of his power, he and his Lady Sif are on the outs, and enemies old and new abound. Vibrantly re-colored for this printing.

Smith, Jeff
Bone, vol. 1: *Out From Boneville*
GRAPHIX/Scholastic, 2005
ISBN 978-0439706230
$26.99

Smith's *Bone* series ran in nine volumes from 1991-2004 under his own imprint, Cartoon Books, and won both national and international awards. Reprinted by Scholastic in color beginning in 2005, it tells the story of three Bone cousins lost in a pre-technological world caught up in a battle for control of the valley. By turns dramatic and humorous, Smith's skills are consummate, and the books have delighted readers of all ages. *Out from Boneville* begins the story as the three cousins are run out of Boneville, only to find they are far from any world they know and have few skills with which which to survive. Other books in the series are: *The Great Cow Race, Eyes of the Storm, The Dragonslayer, Rock Jaw Master of the Eastern Border, Old Man's Cave, Ghost Circles, Treasure Hunters*, and *Crown of Thorns*. Cartoon Books also collected the entire series as one huge book entitled *Bone: One Volume*.

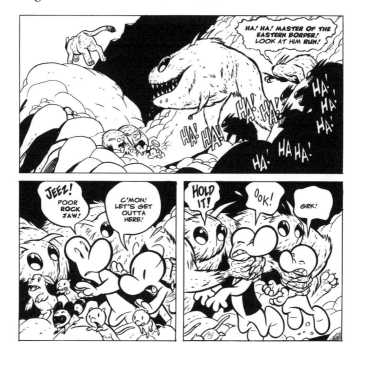

Smith, Jeff
RASL
Cartoon Books, 2013
ISBN 978-1888963373
$39.95
This story of a hard drinking, dimension-traveling scientist/art thief, complicated hero, *RASL* takes a dramatic turn when it's revealed that RASL holds the lost journals of Nicholas Tesla, a rival of Thomas Edison's. While everybody doesn't want to recover the art RASL stole, everybody does want the journals. How RASL manages to save the world as he knows it is both ingenious and bitter. The dialogue is sure, the science is sound, and the visuals brilliant.

Spiegelman, Art
Maus: A Survivor's Tale
Pantheon Books, 1996
ISBN 978-0141014081
$20.87
This book collects both *Maus* volumes, *My Father Bleeds History* and *And Here My Troubles Began.* Volume 1 describes Spiegelman's father Vladek's struggle to survive concentration camps during World War II. Volume 2 relates the trials of Spiegelman's parents as they build a life in America. Awarded the Pulitzer Prize in 1992, *Maus* is in part a meditation on fame and success, and an exploration into familial responsibility, as Spiegelman asks what his debt is to his deranged father, and whether or not commercial success is rewarding if the price is lost autonomy. Arguably the most important work of comic art ever published.

Starlin, Jim, and Steve Englehart, Doug Moench and Pat Broderick
The Death of Captain Marvel
Marvel, 2013
ISBN 978-0785168041
$19.99
One of the first superhero graphic novels, originally published in the 1980s, this is the final story of Mar-Vell, the alien Kree warrior fighting for humanity (no connection to the Fawcett Comics character of the 1940s and '50s). Mar-Vell contracted cancer years before but it had gone into remission. In this final episode he relives his life, as friends past and present say good-bye. Notable for its affecting storyline and no-nonsense artwork, *The Death of Captain Marvel* remains important because few heroes actually die in comics, and as such, this book raises many questions other superhero comics skim over.

Superstars [top Archie creators from over the decades]
Archie, the Best of Archie Comics, vol. 3
Archie Comics
2011
ISBN 978-1879794849
$9.95
Archie, Veronica, Betty, Reggie and Jughead have become American icons, and their romantic struggles and triumphs have influenced our culture and our perceptions of teenage life, as well as inspiring feature films and television programs. This volume collects many of the characters' early stories. Part of an ongoing reprint series.

Talbot, Bryan
The Tale of One Bad Rat
Dark Horse Books, 2010
ISBN 978-1595824936
$19.99
The title of this affecting book is a nod to Beatrix Potter, whose books inspire protagonist Helen in her flight from an abusive father. As she flees, Helen follows the trail of Potter in an effort to gain the strength to move on, as the abuse has ended. After

a joust with the police, Helen lands a job at an inn once visited by Potter, and over time reaches the inner resolve necessary to confront her parents and take control of her life.

Tamaki, Mariko and Jillian Tamaki
This One Summer
First Second, 2014
ISBN: 978-1596437746
$17.99

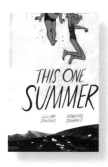

This coming of age story features Rose, who summers with her mother and father near her summer best friend Windy. This summer is different because Rose is getting older and because her mother and father fight incessantly. There's something wrong here, but Rose can't quite put her finger on it. Rose is learning the adult world is very complicated. Gorgeously illustrated in soft colors, with sure, understated dialogue, this book grabs hold of the reader and won't let go.

Tamaki, Mariko and Jillian Tamaki
Skim
Groundwood Books Reprint Edition, 2010
ISBN 978-0888999641
$12.95
Skim is the story of Kim (also known as Skim) a teen Goth who
has a lot on her plate. Her parents are involved in an acrimonious
divorce, and her friend's boyfriend has committed suicide. The
only cool person in Skim's life is her English teacher, Ms. Archer,
who Skim develops a crush on. This crush helps her resolve her
issues with identity and self growth. The story is told in soft,
blurry brushwork, and the writing is insightful, making this a go-to
book for anyone looking for a good story of adolescent angst.

Tan, Shaun
The Arrival
Arthur A. Levine Books, 2007
ISBN 978-0439895293
$19.95
Several lives and stories intersect in Tan's birds' eye view of
an immigrant arriving in a shining city. Told wordlessly, these
washed-out illustrations resemble old photographs, adding to the
general feeling of unease, as immigrants experience anxiety, sad-
ness, and the surreal. The drawings are exquisitely and immacu-
lately rendered. A book you can read numerous times, experienc-
ing a new story each time.

Tatsumi, Yoshiro
A Drifting Life
Drawn and Quarterly, 2009
ISBN 978-1897299746
$34.95
This mammoth memoir records Manga artist Tatsumi's life from
1945-1960 as he tried to break into comics. To get there, young
Tatsumi has to confront his family's financial difficulties, health
issues, and his parents' failing marriage. This book stands out
because of the quality of the art and the depth of the character-
izations, but most importantly because Tatsumi casts a hard and
unflinching eye upon himself.

Telgemeier, Raina
Smile
Graphix, 2010
ISBN 978-0545132060
$10.99

A freak accident knocked cartoonist Telgemeier's two front teeth out when she was 12. This began her dental nightmare, recounted in *Smile*, that included implants, complicated retainers, and braces. All the traumatic events are presented to the reader in a style that is both jarring and warm, as time has softened the blow. *Smile* covers the normally difficult period of middle school and the beginning of high school, where the cartoonist experiences, in addition to her dental problems, the relatable growing pains of puberty, loss of elementary school friends, and the increased expectations put on her. The book ends on a bright note, and the story itself is ultimately warm, but it's Telgemeier's style—at once whimsical, dramatic, evocative, and intimate—that makes *Smile* work so well.

Tezuka, Osamu
Buddha, vol. 1: *Kapilavastu*
Vertical, 2006
ISBN 978-1932234565
$14.95

In *Buddha*, a fictionalized tale of the religious leader in eight volumes, Tezuka interprets the young man's life in a manner similar to Herman Hesse's prose novel, *Siddhartha*. Other volumes in the series: *The Four Encounters*, *Devadatta*, *The Forest of Uruvela*, *Deer Park*, *Ananda*, *Prince Ajatasattu*, and *Jetavana*.

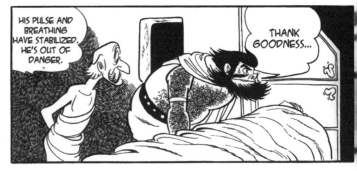

Tezuka, Osamu
Ode to Kirihito
Vertical 2 Editions, 2010
ISBN 978-1934287972
$14.95
Manga master Tezuka is at top form in this tale of Kirihito, an idealistic young doctor sent to a rural community to investigate the fatal "Monmow" disease, which turns humans into dogs. After becoming infected, Kirihito finds a way to stop the disease, but he's already half animal, and he's treated as such by humans, even as those close to him betray him. This is a mammoth story and the black-and-white line art reflects that—at times frantic, other times soft, other times violent, and still other times goofy. Prepare for a long night when you pick this one up.

Thompson, Craig
Blankets: An Illustrated Novel
Top Shelf Productions, 2003
ISBN 978-1891830433
$29.95
Thompson's first book, *Goodbye Chunky Rice*, was a cult hit, but *Blankets* is a breakout book, detailing his experiences growing up in a fundamentalist Christian household. Thompson is in complete command of his material, and his illustration style is deft, unsentimental, and affecting. Weighing in at just under 600 pages, this book may be the longest American graphic novel originally published in one volume.

Tomine, Adrian
Shortcomings
Drawn and Quarterly, 2009
ISBN 978-1897299753
$14.95
30-year-old Ben Tanaka seems to have a good life, a beautiful, lively girlfriend, and a fulfilling job, but he is attracted to white women. In this examination of racial identity and character,

Tomine frankly lays out the complications for people of color obsessed with whiteness: isolation, confusion, and a wavering sense of identity. Tomine's exacting, artwork illuminates through facial expression and gesture and attention to detail. His dialogue is crisp and equally exacting and perfectly complements the drawings.

Vaughan, Brian K., and Fiona Staples
Saga, vol. 1
Image Comics, 2012
ISBN 978-1607066019
$9.99
Marko and Alana are members of opposing races engaged in an interplanetary war. The couple can't seem to agree on anything, except that they're in love and have a baby both sides wants to eliminate. With the help of a ghost, they escape on a rocket ship that has a mind of its own, looking for a place to raise their child in peace. Unfortunately, peace is not to be found. Evocative artwork, taut writing, and a checkered cast give this book its individuality. Part of an ongoing series.

Ward, Lynd
God's Man: A Novel in Woodcuts
Dover Publications, 2004
ISBN 978-0486435008
$9.95
Originally published in 1929 and told in vibrant, inviting woodcuts, this wordless narrative from Caldecott Medalist Ward (*The Biggest Bear*) tells the story of a poor artist who makes a bargain with a mysterious stranger who gives him a magic paintbrush. With it, the artist rises quickly in the art world, only to be bitterly disappointed by the corruption he finds. After a scuffle with the police, he is injured and is nursed back to health by a woman living in a wood. The couple has a child and life is satisfying until the stranger returns.

Ware, Chris
Building Stories
Pantheon Books, 2012
ISBN 978-0375424335
$50.00

This unique book doesn't come between two covers. It comes in a box and consists of 14 separate graphic elements for readers to hold that move back and forth in time: newspapers, flip books, books, even a board game. These pieces mostly focus on a nameless woman living in Chicago who is missing a leg. Readers follow the woman from childhood into adulthood when she becomes a parent. Meticulously drawn and colored in soft hues that are easy on the eyes, and with lettering as creatively placed as the artwork, *Building Stories* won multiple awards, including Eisner and Harvey awards, as well as awards outside of the comics industry. Because of the numerous components to this "book box," one doesn't read it as one reads a book enclosed between two covers. One experiences it while investigating the various components. Plan to spend a few evenings unraveling the mystery that is *Building Stories.*

Ware, Chris
Jimmy Corrigan, the Smartest Kid on Earth
Pantheon Books, 2003
ISBN 978-0375714542
$19.95

Winner of the *Guardian's* First Book award, *The* American Book award and many others, *Jimmy Corrigan* tells the story of middle-aged Jimmy Corrigan's meeting with his father over a Thanksgiving weekend. Jimmy's social outlets are few and his mother overbearing. One of his few escapes is through fantasies where Jimmy imagines himself the smartest boy on earth. A parallel plotline involves Jimmy's grandfather at the 1893 Chicago World's Fair, where he is mistreated by his own father.

What makes this book so compelling is cartoonist Ware's style, which ranges from minute detailed panels to large spreads. The coloring is fine-tuned to reflect the muted, isolated state of Jimmy's mind. The writing is carefully placed within the panels, making reading the book itself sometimes a challenge, like an

elaborate puzzle. *Jimmy Corrigan* is a hard, rewarding read, and cited by many as the best American graphic novel produced so far.

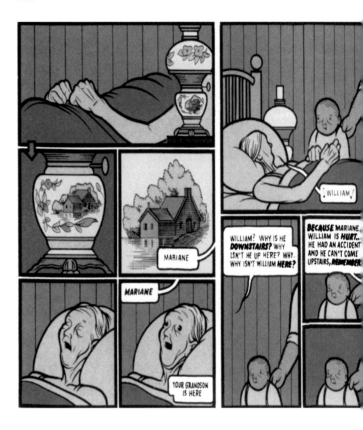

Willingham, Bill, and Lan Medina
Fables, vol. 1: *Legends in Exile*
Vertigo, 2012
ISBN 978-1401237554
$12.99
This series re-imagines characters from fairy tales in a modern world. In *Fables,* the heroes of various tales are found living together in Fabletown, New York. Snow White rules Fabletown, and the Big Bad Wolf is a detective. Other well-known characters round out the cast. While the art is solid and serviceable, this series stands out because Willingham is a creative and witty writer who gives the fairy tale characters very human traits. This

volume includes a prose story by Willingham telling us
how Wolf became a detective. Part of an ongoing series.

Winnick, Judd
Pedro & Me: Friendship, Loss, and what I Learned
Square Fish First Edition, 2009
ISBN 978-0805089646
$17.99

When young Judd Winnick, looking to make a name
for himself, joined the cast of MTV's *The Real World* in
1993, he didn't know that one of his housemates had
contracted AIDS. The story of their friendship, as well as
Winnick's relationship with the other cast-mates, is told
in simple, affecting black-and-white drawings partnered
with a lot of powerful writing. The book is both affecting
and instructive, as Winnick overcomes his bias against
AIDS through education and compassion for his new
friend. The real star is 22-year-old Pedro Zamora, who
joined the cast to bring AIDS awareness to the MTV audi-
ence. Have a tissue handy for this one.

Yang, Gene Luen
American Born Chinese
Square Fish Reprint Edition, 2008
ISBN 978-0312384487
$9.99

This book, winner of the Printz award for best Young
Adult book from the American Library Association, and
a finalist for the National Book Award, tells three inter-
twining stories at once: the struggles of middle schooler
Jin Wang as he attempts to fit in with his peers; the saga
of the Chinese hero, Monkey King, who wants to be
revered, and the story of Danny, who is shamed by his
stereotypical Chinese cousin.
Yang is a subtle and powerful storyteller. With little
narration, sparse dialogue, and clear, soft color illustra-
tions, readers experience each character, emerging with
a deeper understanding of the complexity
of identity.

Yang, Gene Luen
Boxers & Saints (two-volume boxed set)
First Second, 2013
ISBN 978-1596439245
$34.99

Set during China's Boxer Rebellion of 1898, these two books present opposing sides of the impact the West had on rural China. In *Boxers*, missionaries and soldiers bring technology and new ideas, but they also destroy numerous Chinese beliefs and traditions. To retaliate, hero Bao becomes a warrior, believing that an ancient Chinese practice makes him and his roving army impervious to Western bullets.

In *Saints*, the companion volume, young Chinese woman Four-Girl converts to Catholicism, joining the same church that terrorized Bao's village. Four-Girl is visited by the spirit of Joan D'Arc, giving her life purpose. Yang's clear, cartoony style is highly effective in depicting both the reasoning behind the warrior bands and the draw of Western religion, as well as the inevitability of the West prying open the doors to China.

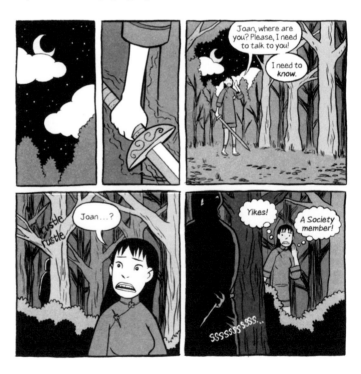

Further Reading: 12 Books about Comics and Graphic Novels

Chabon, Michael
The Amazing Adventures of Kavalier & Clay
Random House, 2012
ISBN 978-0812983586
$17.00
Chabon's novel, set during the early days of the comic-book industry, tells the story of immigrant cousins Joe Kavalier and Sammy Clay, both modeled on early comic book creators. In the novel, Kavalier and Clay create a hit character, the Escapist. Wrapped inside this story of unrequited love and repressed lives Chabon retells the story of the Senate comics investigation of the 1950s, and the creation of the Comics Code Authority. Awarded the Pulitzer Prize, *Kavalier & Clay* is the most important novel ever written about the comic-book industry.

Eisner, Will
Comics and Sequential Art: Principles and Practices from the Legendary Cartoonist
W.W. Norton & Company, 2008
ISBN 978-0393331264
$22.95
Comics grandmaster Eisner draws upon a career of creating and packaging comics and graphic novels, as well as many years teaching at the School of Visual Arts, as he explains and demonstrates how sequential art is produced and why its effect is so powerful. Fully illustrated in black and white. The author includes numerous historical and international examples.

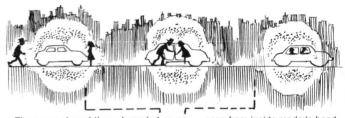

The scene viewed through reader's eyes . . . seen from inside reader's head.

Final Panel selected from sequence of action.

Ferraiolo, Jack D.
Sidekicks
Abrams, 2011
ISBN 978-0810998032
$16.95
Bright Boy, superhero Phantom Justice's teenage sidekick, realizes that he's growing into an adult and wants an independent life of his own, away from Phantom Justice. With laugh-out-loud humor and insight, this teen novel uses superhero motifs and metaphors to illustrate problems we all face.

Jones, Gerard
Men of Tomorrow:
Geeks, Gangsters, and the Birth
of the Comic Book
Basic Books, 2005
ISBN 978-0465036578
$19.99
Jones, a comic book writer and the co-author of a few comic book histories, vividly brings to life the creation of the American comic book, which evolved out of the science fiction movement of the 1920s, and landed squarely in the middle of popular culture with the first Superman story in 1938. Jones seasons the book with biographies of the major players—mostly young Jewish men with a creative bent and few places to turn. The book also traces the evolution of Jerry Siegel and Joe Shuster's ultimately successful battle for recognition as the creators of Superman, one of the most enduring characters of 20th century popular culture.

Kitchen, Denis and Paul Buhle
The Art of Harvey Kurtzman: The Mad Genius of Comics
Abrams Comic Arts, 2009
ISBN 978-0810972964
$45.00
Harvey Kurtzman was the legendary genius behind *MAD* magazine and EC's hard-hitting 1950s war comics. This beautifully-produced book includes extensive biographical notes as well as

full coverage of Kurtzman's *MAD* years. The volume is lavishly illustrated with samples of Kurtzman's work over the years, including excerpts from *Hey Look!*, *Little Annie Fanny*, *Help!* and *Trump*.

Levitz, Paul
The Golden Age of DC Comics
Taschen America, 2013
ISBN 978-3836535731
$59.99
With the introduction of Superman in *Action Comics* #1 in 1938, a new kind of hero was created: the superhero. Costumed and supremely powerful, these heroes could do what ordinary people couldn't. In *The Golden Age of DC Comics*, Levitz recounts the history of DC, from its pre-superhero origins to the McCarthy era. Of particular interest is an interview with premier artist Joe Kubert. Heavily illustrated.

Morrison, Grant
Supergods: What Masked Vigilantes, Miraculous Mutants, and a Sun God from Smallville Can Teach Us About Being Human
Spiegel & Grau Reprint Edition, 2012
ISBN 978-0812981384
$16.00
Popular comic book writer Morrison's bird's eye overview of the history of American comics is opinioned in the best way, written by someone who lived through much of the history recounted in the book. What separates it from other histories are not only Morrison's opinions, but his ability to insert himself unsparingly as a character in the ongoing drama. Fun and educational.

Robbins, Trina
Pretty in Ink: North American Women Cartoonists 1896-2013
Fantagraphics, 2013
ISBN 978-1606996690
$29.99
Robbins is the preeminent historian focusing on women in

American comics. In this book she traces the history of female comics creators, giving ample space to both historically important figures as well as prominent modern-day creators. The section about women cartoonists of the 1960s-1970s is of particular interest. Illustrated heavily in black-and-white, this book also includes numerous color plates.

Spiegelman, Art
Co-Mix: A Retrospective of Comics, Graphics, and Scraps
Drawn and Quarterly, 2013
ISBN 978-1770461147
$39.95
Spiegelman is best known, of course, for *Maus*, his memoir of his father's survival of the Holocaust. This catalog from a 2013-2014 exhibition exposes the reader to the full range of Spiegelman's work—from early underground comic strips to the beginnings of *Maus* to *New Yorker* magazine covers. Reproduced both in black-and-white and in color, from small strips to full page renderings, this book gives readers a new appreciation for one of this generation's premier cartoonists.

Thompson, Jason
Manga: The Complete Guide
Del Rey, 2007
ISBN 978-0345485908
$19.95
This guide reviews over 900 manga (Japanese comics) series, provides background information on the same series and their artists, and rates the series. It also indicates age-appropriateness for the series, and profiles several big-time manga creators. It includes a glossary of manga terminology and an overview of manga history. Black-and-white illustrations complement the text.

Out of print, but well worth hunting down:

Feiffer, Jules
The Great Comic Book Heroes
Dial, 1965
Fantagraphics pb. reprint, 2003, ISBN 978-1560975014
Feiffer's seminal book, which jump-started fandom in the 1960s and re-started Will Eisner's career in comics, remains vital. A loving, biting essay about Feiffer's own childhood relationship with comics, and an unflinching look at the comic book industry when he was a young professional working for Eisner, this book also contains early stories of heroes created in the late 1930s and early 1940s, including Superman, Batman, Wonder Woman, and others. Most later editions don't include the comics themselves, so seek out one that does.

Patrick Rosenkranz
Rebel Visions: The Underground Comix Revolution 1963-1975
Fantagraphics Books, 2003
ISBN 978-1560974642
$39.95
The "underground comix" were first conceived amidst the hippie revolution of the 1960s, and popularized by R. Crumb's *Zap!* in 1968. This well-produced, heavily illustrated book traces the history of the underground movement and highlights prominent creators.

Select Movies about Comics and Graphic Novels

The Cartoonist: Jeff Smith,
Bone, and the Changing Face of Comics
A good overview of Jeff Smith's career and the rise of the graphic novel format.

Comic Book Confidential:
20th Anniversary Edition
This documentary profiles 22 comic book and comic strip creators.

Crumb (Special Edition)
A biopic of underground comix superstar R. Crumb.

Will Eisner: Portrait of a Sequential Artist
A career-spanning look at the man who, among other things, was instrumental in popularizing the graphic novel, and was also one of its most brilliant practitioners.

Superheroes: A Never-Ending Battle
A study of superheroes from their beginnings in the late 1930s to the modern day.

Title Index

Title Index

Title Index

Other books by Stephen Weiner

The Will Eisner Companion
with N.C. Christopher Couch

Faster Than a Speeding Bullet: The Rise of the Graphic Novel

100 Graphic Novels for Public Libraries

Bring an Author to Your Library

The Bone Companion

Hellboy: the Companion (with Jason Hall and Victoria Blake)

Tom's House

We have over 200 graphic novels available
Visit our Web site to view our complete catalog
and order any of our publications.
Librarians: visit our Library page at our website for recommendations

NBM
160 Broadway, Suite 700, East Wing
New York, NY 10038
Catalog available upon request

nbmpub.com

Biographies

Stephen Weiner has been writing about comics since 1992, and is the most recognized librarian responsible for promoting graphic novel collections in public libraries. His books include: *100 Graphic Novels for Public Libraries, The 101 Best Graphic Novels,* and *Faster than a Speeding Bullet: the Rise of the Graphic Novel.* He is co-author of *The Will Eisner Companion, Hellboy: the Companion,* and *Using Graphic Novels with Children and Teens: a Guide for Teachers and Librarians.* A frequent speaker at national conventions, he served as co-editor of the seven volume series *Critical Survey of Graphic Novels.* In addition, he has written a novel, *Tom's House.* A recipient of the Comic Creator's Guild award, he is Director of the Maynard Public Library in Maynard, Massachusetts.

Danny Fingeroth was a longtime writer and editor at Marvel Comics and has written stories for comics anthologies including Studs Terkel's *Working.* He is the author of *Superman on the Couch: What Superheroes Really Tell Us About Ourselves and Our Society; Disguised as Clark Kent: Jews, Comics, and the Creation of the Superhero;* and *The Rough Guide to Graphic Novels.* He co-edited, with Roy Thomas, *The Stan Lee Universe,* featuring rarities from the legend's career. He was Sr. VP of Education at The Museum of Comic and Cartoon Art (MoCCA), and has taught comics there and at other venues including The New School and NYU. Danny currently serves as a creative consultant to Will Eisner Studios and Wizard World Comics Conventions and continues to write and speak on comics and graphic novel-related topics. Find out more at www.dannyfingeroth.com.